SOUL SEEDS

SOUL SEEDS

REVELATIONS & DRAWINGS

CAROLYN MARY KLEEFELD

Foreword by Laura Archera Huxley

Cross-Cultural Communications
Merrick, New York
2008

Some of the sayings in *Soul Seeds* have appeared in other contexts in Carolyn's books,
Climates of the Mind and *The Alchemy of Possibility: Reinventing Your Personal Mythology.*
The other sayings were taken from Carolyn's journals written from 1997 through 2008.
Many of the sayings, together with Carolyn's fine art, were exhibited in the show,
A Journey to the Healing Place: Healing Through Art, Poetry and Reflective Prose, at the
City Hall, Seaside, California, October 2002.

Inquiries about *Soul Seeds* should be addressed to

Cross-Cultural Communications
239 Wynsum Avenue
Merrick, New York 11566-4725 USA
(516) 868-5635
(516) 379-1901 Fax
cccpoetry@aol.com
www.cross-culturalcommunications.com

For more information on Carolyn's artwork and her other published books,
please visit www.carolynmarykleefeld.com

Library of Congress Control Number: 2008934068
ISBN 978-0-89304-089-5

Design by MaddoxDesign.net
Cover, *Tree Raku* by Carolyn Mary Kleefeld, oil on canvas 40" x 30"
Author's photograph, Dennis Wyszynski

First Printing 2008
Printed in United States of America by UBS Printing

I dedicate Soul Seeds *to*

my beloved friend and muse, Laura Archera Huxley.

You exemplified in both your living and in your dying

how to make the impossible possible.

You live on within me as an undying torch

of love and inspiration.

ACKNOWLEDGMENTS

To all the angel-guardians who, in their own extraordinary ways, have added their gold to these seeds.

To the cherished godmothers of *Soul Seeds*:
Kirtana, wild dove who sings beautiful and profound songs, and whose patient angel heart and organizational genius edited and cultivated these seeds over many moons.

And Patricia Holt, the flaming unicorn who travels with me on wondrous and creative philosophical journeys, and whose vast generosity of being is deeply rooted to my work, making this compilation and subsequent publication possible.

To David Wayne Dunn with my deep love and great appreciation for our rare poetic camaraderie and for your most extraordinary and inspiring creative works.

The ground of these seeds was greatly enriched by Ronna Emmons, artist and teacher extraordinaire, with whom I have shared many magical safaris of creative experiment and discovery.

My heartfelt gratitude to Michael Zakian for your brilliant expertise as a museum curator and art history professor. You have opened the doors for my soul seeds to communicate with a larger world. I deeply appreciate your sensitivity and the expansiveness of your vision.

My loving gratitude also goes to John Dotson, Stanley H. Barkan, David Jay Brown, and Birgit Maddox for your most essential contributions. Also to Deanna McKinstry-Edwards, PhD, Dr. Piero Ferrucci, Chungliang Al Huang, Evelyne Blau, Dr. Mani Bhaumik, and Kodiak Greenwood.

With extra special love and gratitude to John Larson, the guardian of Pankosmion and patient Noah of the Ark, for your exceptional care and devotion.

With endless love and appreciation to angel-guardians Linda Parker and Laura Zabrowski for your outstanding generosity, loyalty and dynamic capabilities.

With much love and appreciation also to the golden souls of Gail Bengard, Marla Bell, Alice and Gina Russell, Lia Zakian, Linda Jacobson, David Campagna, Cathy Jaeger, Valerie Corral, Natalie Van Allen, Sarah Staples, Auspet Jordan, Jai Italiander, Edna Isman, Marilyn Bihari, Michael Emmons, Scott Parker, Sharyn Adams, Evan Landy, Shanna Mahin, Dr. Roy and Anita Auerbach, Ray Smith and Ralph Abraham, Carla Kleefeld and Celeste Worl, Dr. Paul Fleiss, Dr. Ralph Potkin and Eugenia Galvas, George and Peggy DiCaprio, Dr. Bernfried Nugel, Butch Shuman, Karen and Kaya Pfeiffer, Dan Hirsch, Diane Whitmore, Dorothy Tomezesko, Stacey and Dean Chamberlain, Michael Frederick, Oscar Nolan and Glen Cheda,

Barbara and David Simonich, Tom and Paula Mallet, David and Elva Mendez, Luis P. Gutierrez, and Juana Vargas De Ponce.

And to my mentors and beloved comrades who inspire from beyond the concept of death, Dr. Carl Faber, Edmund Kara, Barry Taper, Freda Taper, Dr. Timothy Leary, Dr. Oscar Janiger, Terence McKenna, Nina Graboi, Dr. John Lilly, William Melamed, and the unmentioned others.

To my father, "Pops," Mark Taper, and my mother Amelia and the generations of ancestors who pulse on through me.

I wait as a Taoist spy for a chance to decipher the unseen forces behind the visible. In the Big Sur wilderness I inhabit, the forces of Nature are supremely powerful and explicit. I recognize many of these same forces in my colleagues and friends, and acknowledge their unique and diverse powers of dedication, their thrust to re-alchemize matter into spirit. I am most grateful for this ever-expanding circle of light.

—Carolyn Mary Kleefeld
July 17, 2008

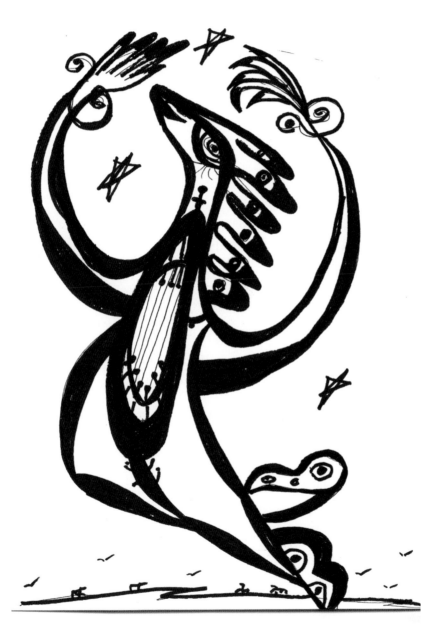

CONTENTS

DRAWINGS

FOREWORD

Reader beware! Not only are you reading richly imagined poetry, but if you apply almost any one of these 'soul seeds,' you will have a deep awakening. Choose the one to which you respond, and see what happens.

Let yourself be enchanted by these evanescent images, varying flights in the immensity of the Universe, yet be sustained by a structure based on knowledge and experience.

Carolyn Mary Kleefeld's *Soul Seeds* offers psychological and emotional guidance expressed in a higher key—clothed in all kinds of magnificent color and worldly expression.

Experience these 'soul seeds' as psycho-spiritual meditations and they may bring about a transformation greater than many hours of therapy.

—*Laura Archera Huxley*
Author, *You Are Not the Target* and *This Timeless Moment*,
founder, president, Children: Our Ultimate Investment

PROLOGUE

At a time when separatist ideologies imperil the Earth and humanity's future, Carolyn Mary Kleefeld's *Soul Seeds* is medicine for the beleaguered soul of humanity. In language poetic and crystalline, each one of the seeds in this book has the power to open worlds of expressive and expanded thinking. It offers its readers a dialogue in the Mystery of who and what life may be as it roots and blooms between the invisible and visible currents and rhythms of earthly life.

Only an artist who has braved the bewildering, rapturous and oftentimes treacherous voices and weather of soul, as Ms. Kleefeld does, could write with such luminosity and inspiration. Breathtakingly wise.

—Deanna McKinstry-Edwards, PhD

PORTAL TO THE ORACLE WITHIN

Although *Soul Seeds* masquerades as merely a paper-and-ink book, this living oracle offers valuable guidance for navigating from the limited to the more liberated realms.

As with Carolyn Mary Kleefeld's earlier book *The Alchemy of Possibility, Souls Seeds* is an experiential guide to self-discovery, with the opportunity for many 'aha' moments. Like the Tarot or the I Ching, it can be used as an interactive, oracular tool, by posing a question, then opening the book at random to see what fresh insight may be gained from a particular 'soul seed'.

Each 'soul seed', when experienced by a fertile mind, has the potential to sprout, take root, and grow into a whole garden of personally meaningful revelations. Like whispers from our DNA, or the divine messages we encounter in dreams, these exquisitely and succinctly-expressed 'soul seeds' are like bejeweled, prismatic mirrors reflecting back the message that we are 'ready' to hear, in the synchronicity of the moment.

The intent of this book is to provide an evolutionary shift in perspective that awakens and frees the spirit when the mind is stuck in culturally-conditioned ways of thinking. It also serves as a manual for the alchemical transformation of consciousness. Like a trusted companion, keep *Soul Seeds* by your bedside, carry it with you

wherever you go, and consult it when you're feeling confused about life or curious about the timeless truths that lie beyond the veil. It will help open your eyes to infinite possibility, and graciously guide you to the celestial secrets awaiting within.

—*David Jay Brown*
Author, *Mavericks of the Mind* and
Conversations on the Edge of the Apocalypse

1. THE ONENESS UNDERLYING MULTIPLICITY

Each of us is a flame within the eternal kiln,
casting an essential ray into infinity.

❖

We are all forces and instruments of Nature
expressing her every whisper and scream
in an ever-evolving symphony of creation.

❖

When we transcend our dualities,
we understand that within our diversity lies our reconciliation.

❖

It is in the Whole of something that holiness may appear.

❖

If we censor our receptivity to any facet of humanity,
we censor that part of ourselves.

❖

Every living thing has invisible tendrils
reaching out in all directions.
Each pebble that falls adds another current to infinity's pools.
So it is that each person's suffering can be felt by all.

May we comprehend our deepest nature,
its relationship to the Whole,
as we weave our fabric of destiny into the Vast Loom.
It is our survival.

❖

Each day is a weaving in the Continuum,
an integration that composes the chords of time
into the eternal symphony.

❖

Life is a kiln of mosaics vibrating in the heat,
each piece fitting together in a giant jigsaw of diverse design.

❖

What is happening to the human species,
to our Earth, also affects galactic life in unimaginable ways.

❖

We will have less impoverishment when we account for ourselves
and our effect on every other living creature.

❖

As we dissolve the arbitrary boundaries of our countries, our souls,
we build bridges of compassion,
transcending the separation born of defense.

Who are we to judge Mother Nature
or decide who is superior or inferior, enlightened or barbaric.
All exist as ingredients in the Cosmic Soup
and are essential in their own unique ways,
regardless of our evaluation.

❖

To evolve, we must be aware of the unified pulse
of every living creature.
Every abuse inflicted has a boomerang effect.
Every bar that imprisons one, wounds all.

❖

If we have compassion for all that exists,
we are in dialogue with the emerald whispers of the universe.
The myriad translations of the infinite symphony
will reverberate throughout our labyrinthine interiors.

❖

We are our own self-referencing stars;
when in harmony with the Whole, we resonate with all of creation.

❖

In the Oneness underlying Multiplicity,
the countless contradictions of life are reconciled.

2. INNER AUTHORITY

May our highest intention lead us in our pursuits,
independent of consequence.

❖

Genuine process is not the imitation of another's beliefs.
True authority is authorship for oneself.

❖

Be simple, direct—true to your soul;
otherwise the clumsy furniture of the mind clutters perception.

❖

In listening to our souls, we cultivate ourselves, the Earth.
Without our inward soul-trodden path, our gardens are desert isles,
isolated from the vast streams of other spirits, alien unto ourselves.

❖

In the gradual process of enlightenment,
the theories and philosophies of others may ignite or validate us,
but only our direct experience
will dawn the light of our inward sun,
illuminating our unique path to the kingdom within.

Why clip the wings of Pegasus
with the shears of expectant hope.
Let your dreams orchestrate your heart's lullaby
and soar to the rhapsodic.

❖

Although we are fountains of Nature's forces,
captives of our genetic seed,
the flame of our spirits
is capable of navigating toward our highest potential.

❖

Our light is beamed from our inner ecology and self-knowledge.
When we accept and respect our individuality,
we give ourselves the freedom and space
essential for our inherent nature to blossom.

3. LIVING BOLDLY

To live the precipice between life and death
is a precarious balance of living the edges,
navigating with sublime intuition.
It takes as much courage to live this way
as it does to fight on the very battlefields of war.
As acrobats in the cosmic gymnasium,
the more we dare to live the edges,
the further our stretch into the Divine.

❖

Being brave is a full-time sport; we must stand tall as outsiders,
uniting with other renegades, other anarchists of the caged spirit.

❖

To walk uplifted in the world requires both balance and vigilance.

❖

Be bold, be willing to be alone with your truth;
revere it as your crucible of light.

❖

Few of us have the capacity for truth.
Fewer yet are brave enough to utter it.

Marrowless teachings grow skeletal prisons.

❖

Fear chooses prejudice and defense
instead of embracing philosophy and enlightenment.

❖

Being an anarchist of the spirit requires total risk—
risk of alienation, risk of being misunderstood
and of sometimes not understanding oneself.

❖

We can give ourselves wings, the right to be free spirits,
to live this transient life as if we were immortal,
and yet cherish every moment as if it is our last.

❖

We never have it all,
unless we risk what we think all to be.

4. SILENCE ANSWERS US

The answer is to be so quiet that the questions stop.

❖

Pause in motion is one of Nature's basic rhythms.

❖

Ah, what peace is possible when we can dwell
in the silent depths of being
which underlie the chaos of manifestation.

❖

Silence answers us in our mirrored lake of repose.

❖

From a relaxed state of being, the seminal may gestate.
When free of anxiety or defense,
we are in tune with the resonant knowledge,
the platonic wisdoms murmuring from the primordial pools.

❖

The mind creates unnecessary toil for the body,
especially when we are unsettled and chaotic.

The wilderness of the unconscious offers infinite travel
without having to wait in lines.

◈

The eternal roots of being are expanded in *not doing*.
In that lush Emptiness, we have the opportunity
to die to that moment—
and be reborn in the womb of the Invisible.

◈

In being stillness, intuition calmly guides;
decisions come of their own accord, in their own time.

◈

Corruption dissolves when we are in communion
with the silent lake of our souls.

◈

Listen carefully, because it is in the stillness between the words
that the secret music can be heard.

5. THE ETERNAL MOMENT

We receive messages spontaneously, without thought,
where treasure is always found—
in the present moment, beyond our simulations or mental plans.

❖

We cannot force anything essential;
our rushing is a sign of anxiety, a lack of cosmic perspective.

❖

Since living on a schedule
can deaden the senses, the spirit adventure,
why not allow ourselves, as much as possible,
the wonder of being lost in discovery.

❖

Our memories can devour the tender seeds of the moment,
preventing the generation of new life.

❖

Hope can burden our wings, limiting the sapience of the Tao.

❖

When we live from the sublime state of the Unconditioned,
little or no accumulation occurs.

Rid your flesh of the past, or the past will live you.

❖

When we let go of summer's over-ripe illusions,
we can begin again in silence,
letting the seed of spring
lie uncorrupted on our altars of reverence.

❖

May we always be beginners, free-falling into the eternal moment.

❖

By releasing outworn patterns, the gestures of the past,
we live amidst the winds of change, embracing the unfamiliar.

❖

When we spin our cocoons into the future,
we leave the present dry.

❖

Sometimes when we feel overwhelmed,
we can just show up for life
and the Tao takes us where we need to go.

Let go of suffering, the abortions of existence,
the smoldering blaze of self-incrimination,
the indigestion of memories rehashed.
Then, wildflowers can sprout from meadows of cleansed heart,
amidst the emerald woodlands.

❖

Free-falling into the moment
can feel as dangerous as parachuting from a plane;
one surrenders to the unknown, to the will of God.

❖

To experience the poetry of the instant
is to be a ballerina reaching into the Beyond.

6. SURFING THE CYCLES OF CHANGE

All is changing; nothing is still.
Even death has its endless changes of form.

❖

In the garden I observe that we echo Nature's cycles and seasons,
discarding dry leaves, rusty concepts—
prejudices that, as dead brush, clutter our views.
We can rejoice in this renewal,
continuing to plant seeds in our marrow-soil,
trusting the mystery that spores regeneration.
By cultivating our inner gardens, we liberate our souls.

❖

Just as the tree whose fruit has fallen,
just as the butterfly who discards its cocoon,
so our bodies are carried by the seasons
through eternal climes of change.

❖

When we fear the unfamiliar, growth is stunted.

❖

We must transplant ourselves when dwarfed and cramped
like a potted plant;
our roots have outgrown their soil.

Within the flower's face is its seed,
the eternal seasons of its changing form.
Within the young maiden's face
is the face of the crone.
And within the face of the crone
is the face of the child
she once was.

❖

Death is inherent in the birth of every beginning.
In our continual dying, in our detachment,
fear is transformed, yielding to wisdom.

❖

When we live in the Unconditioned,
in the effortless rhythms of the Tao,
life becomes a surfing of realities,
of the waves and cycles
of the infinite seasons resounding within.

❖

Our sorrows and woes are the mulch
of our new tomorrows, our new creations.

The conceptual doors of life and death exist only in our minds.

We live in a perpetual state of re-invention.

Our immortality lies in our capacity to re-form;

metamorphosis is the elixir of life.

❖

The cosmos pours its good fortune

and then takes out the plug.

The scales are always re-balancing themselves.

❖

When we see the gardens in their endless seasons,

may we so offer ourselves, yielding to such grace.

7. ECHOES FROM THE PRIMAL TEXT

When we open ourselves to the Holograph of life,
we have access to the resonant knowledge
echoing from the primal texts.

❖

The macrocosm is contained in the microcosm,
the pulse of infinity in every raindrop.

❖

The granule of sand echoes the beach.
A drop of water is no less significant because it is the microcosm,
nor is the sea greater because it is the macrocosm.
Neither exists without the other.

❖

When the magic of synchronicity manifests,
we receive a glimpse of the Grand Design,
which at other times may lie hidden.

❖

If we take life merely literally and not also metaphorically,
we can lose the Spirit of experience and miss the deeper meanings.

❖

Perhaps God is simply our search for God.

The meaning lives beyond the grasp,
beyond external appearance, in the underpinnings of existence.

❖

Meaning is to be discovered
in the subtle hues and textures of Nature's language,
in synchronicity, in the random events that change our lives.

❖

Life is abundant with mystical metaphors and symbols,
which mirror the Greater Existence.
When we perceive events as metaphors,
we open ourselves to an added dimension of the cosmos—
one that can illuminate our psyche's deeper process.

❖

May we listen to that Otherness which is of no man.

❖

'God' is our explanation for the ineffable.

8. SOMATIC EXPERIENCE

Within somatic experience lies molecular knowledge;
our whole being is engaged.
All of us beholds, not just the eye.
This synthesis allows an understanding through all our senses
rather than through only one facet of the cerebral gymnasium.

❖

The answers to our survival and prosperity
lie in the multidimensional aspects of our awareness,
in the synthesis of science
and the ideals of spirit.

❖

The merely conceptual divides the Whole,
severing feeling from mind, producing imbalance,
an isolating maze.

❖

In our calloused society, sensitivity is not valued for its intelligence;
yet genius does not exist without sensitivity.

❖

Why live within the cerebral closets of our minds,
our intuitive sensings so often crushed
into the sardine cans of the mundane.

Our human psychosis is bred from the mind-body-spirit rupture.

◈

Why expose our delicate senses to pollution, in any form;
our aesthetics rely on their acuity.
As elixirs of ecstasy,
they require protection and nourishment to flourish.

◈

In every denial of feeling
is a self-woven grave of numbed sensibilities.

◈

In living the Unconditioned,
our senses are vibrant, receptive, inquiring—
sacred vessels for experiencing
an ever-expanding, intimate dialogue with the Cosmic.

◈

From the aesthetics of acute sensibility,
a particular intelligence emerges.
It is the intelligence of honesty, the gentleness of understanding,
and a compassionate connection to the Earth
that open our receptivity to all that Is.

9. HONORING THE INNER PHYSICIAN

The body is a more honest barometer of truth than the mind.

❖

As immortal beings, we are eternal gardens,
reborn in myriad forms.
Consider the progression of the rose's bud
to its full-petaled blossom;
its fading fruits the seed of tomorrow.
Our philosophy can mirror the flower's cycles.
Let us yield to Nature's mystery, rather than succumb to the fear
that fuels the predatory approach toward aging and death.

❖

Life is a continual process of regeneration and integration,
our awareness being our most essential preventative medicine.
May we treat health issues
with underlying faith in our inner physician.

❖

Our essential nature channels our evolution as well as our demise.
We are who we are because of what we are—
spiritually, emotionally, mentally and biologically.
If we can recognize our multidimensionality,
we can better understand and nurture our health.

Renewal and unexpected healing
are evoked by the playing of our hearts' strings.

◈

We heal from our strengths, not our weaknesses.

◈

Our consciousness offers flexibility to our immune system.

◈

We can fertilize the roots of our brain-forests
with healthy, imaginative thoughts and perceptions
rather than allowing pollution to corrode our consciousness.
Flexibility, resilience and endurance are essential
if our brain-trees are to withstand the shocks of life.
Rooted in our deepest and most fecund soil,
may we offer our trees' branches infinite space to grow,
and our buds the light of awareness
so they may flower and bear fruit.

10. ANSWERING TO OURSELVES

Why live in someone else's home?
We can craft our own spiritual architecture
from the very marrow of existence.
Only we can build our inner temple,
tend the gardens of our inner ecology.

❖

We are one with the myriad cycles of planets, stars and moons.
Let our homage be to the galactic order, within.

❖

The more we believe in ourselves, the less we need to see to believe.

❖

Comparing our capacities with others'
or trying to outdo others for our own sense of importance
is self-defeating, although we may appear to win.
Another rival always exists in this no-win game,
even if that rival is only within ourselves.

❖

There are so many opaque veils to deter us,
seductions offering paths of self-importance,
tempting us to put our energy outward before it goes inward.

So often we are given outfits to wear that dull our innate light.
Then we are forced to dwell in the shadows
until we can see through the layers of conditioning
that eclipse our full radiance.
But can we ever live from our original blueprints again?

❖

Without our ideals, we have no self-reference.
We stare blindly rather than behold.

❖

When we acknowledge that we cannot blame others
for our own limitations,
we begin to assume responsibility for our lives.

❖

Early on we are taught to eyelessly look up to images and symbols
instead of looking first into our own eyes.

❖

We are a world of people all seeking each other's approval,
yet few answer to themselves.
Is it our lack of self-knowledge and acceptance
that causes us to seek definition through the authority of others?

When we cease projecting our shadow selves
and subconscious needs and desires onto 'leaders,'
we will become responsible individuals
and can make significant changes in ourselves and the world.

❖

We can cultivate our own personal mythology,
emanating from an organic and compassionate
connection to all life.
Then, like spiders, we can spin
new comprehensions and interpretations
into the grand suspended Tapestry,
balancing more comfortably in the Unknown.

11. BEING WILLING TO 'NOT KNOW'

The more willing we are to 'not know,'
the more we can live in silent wonder.

❖

Perhaps in grasping to explain life's meaning,
we dissipate its pulse.

❖

The mind can be our ultimate torturer.
Entanglement in the net of excessive thought
can clip and cramp our wings.

❖

Our minds cannot know the greater destiny.
We can only yield, and with awareness, live what *Is*.

❖

Are we capable of standing steadfast, receptive and noble,
bathed in the quietude of no mind's interference?

❖

Why toil with concepts
when the essential occurs from a more discrete design?

Let the winds ripple the surface of our pools,
allowing the images to re-form
without interference by the industry of being human;
when we are less in the mind,
our true work-play can emerge.

❖

May the moon's gaze answer our questions,
and the sun pervade.
May the symphony of existence enter our ears,
and our busy minds go to the gods.

❖

Are we capable of fasting in reverence—
letting go of the mind's gymnastics,
feeding on the glory of Emptiness, reveling in its languor?
What then—but wonder
at that which emanates from this fecund well of being.

❖

How far away ideas can take us—away from *direct* experience.

❖

Let us live our lives in a way that lets the cosmic forces
flow through us without preconceived notions,
and be continually willing to 'not know.'
Then the sacred can emanate from our wandering,
experimenting and exploring of the uncharted.

12. CREATING FROM THE UNCONDITIONED

May we metabolize the poetic as our reality.

❖

In the purity of the Unconditioned, the seed may thrive.

❖

Art is the international language, transcending all boundaries—
no passport is required.

❖

To create art that is from the Unconditioned,
we must live the Unconditioned as a way of life.
When we get out of the way,
the Tao can guide us.

❖

A poet remembers the sensorial, a historian 'the facts.'
The kind of memory we have, in effect, makes us who we are.

❖

Unless fueled by the soul's passion,
words can feel superfluous and limited,
like ashes attempting to speak of a great fire.

One of the magical powers of art
is its capacity to melt isolation
by transmuting our emotions of futility and despair.
Just as the frost of winter incites the flower's bloom,
what could have been just a difficult experience
is transposed into song,
offering a regenerative balm to others.

❖

Art is the silent language of Nature, music for the soul,
birthing new languages of image, and realms of possibilities.

❖

Visionary artists are the messengers between worlds,
avatars of the sublime and its shadows;
they record the timeless
onto a canvas, page, heart of so-called time.

❖

Art without the Mystery is only craft,
which can be impressive but lacks the seminal energy
of the soul, the ineffable.

❖

Art is love in creation,
and love is an art created.

What created in joy will not beget joy?

◈

Drifting isles of imagination await us,
requiring neither baggage nor reservations.
To transmute the density of matter into Spirit
requires the passion of the innocent heart.

◈

The Timeless thrives in the passionate flame of the visionary,
the one who strides beyond the limits
of stale concepts and erroneous belief systems.

◈

Genuine art emanates from the ecstasy of inspiration,
the abrasion of suffering, and the abyss in between.

13. THE WAY OF THE LOVER

Love, the indivisible Cupid, connects us in our diversity,
inspiring union as our primary intention.

❖

To be genuinely loving requires an enduring and devoted nature,
courageous enough to confront the ever-changing climates within.
Only by transcending our survival emotions
may we experience a sacred love,
free of exploitive intent.

❖

Why not create relationships in the way we create art,
continually reinventing ourselves in the process,
using our imaginations rather than society's stereotypes
to express our ideals.

❖

Love is our essential food,
the face of the Ineffable, the one cosmic substance.
In trying to make love visible by packaging it,
we dilute its power, which lies in its subtlety and omnipresence.

As reptilians shed their skins,
so do lovers in their existence together.
As Nature transforms through fires and floods,
so do lovers in evolution, igniting and dissolving.

❖

The mirrors of projection have blinded many a lover.
Who we think is our lover, is also ourselves.
Self-knowledge begins
when we realize we produce this transference.
Otherwise we blame our lover,
instead of exploring our own role
in the unfolding stories of our lives.

❖

Devoted love endures many transitions
of sexuality and camaraderie.
If we view these transitions as changes of form,
rather than as endings,
our suffering diminishes,
and our bond is free to develop into its next form.

❖

Initially our physical attraction to another
may be ignited by a mysterious primal chemistry,
but this bond can become
more powerful, nurturing and transcendent
when infused with a higher spirituality.

Intimacy is a prerequisite to ecstasy.

❖

To love is to fully listen.

❖

Love, like spring rain,
moistens everything, radiating splendor.

❖

From the least expected people
may come the love and encouragement
that touch our hearts and souls.

❖

Why not make love in all we do,
letting spontaneity and intimacy ignite our lives,
rather than living from stale habit.

❖

The way of the lover is to be fully present.

❖

And so, love begets love;
we bring to ourselves what we are.

14. THE AUTONOMY OF NATURE'S LAWS

Underlying the stories we tell
is the autonomy of Nature's laws.

❖

Wilderness is the great integrator, restorer of seed,
where the weariness of the world is erased in uncontrived space.

❖

The mystery of who we are is invisibly imprinted
within every granule of sand and massive mountain.
When we recognize the myriad metaphors of Nature's voice,
we can be guided by the pulse of these oracular codes.

❖

In acknowledging Nature as ourselves,
we can channel her primal energies,
navigating with sublime intuition.

❖

Here, in the wilderness, lives the whim-filled chance called Life.
Miracles may become visible in this dimension
where fabricated reality dissolves.

❖

Nature is indifferent to our explanations of existence.

The woodland, deep and still,

holds resevoirs of silence

accumulated without thought or plan.

❖

When we observe the tides with detachment,

we see that whether the waves

are calm or seething, dashing or placid,

the sea remains the sea, incessantly the underlying source.

❖

In the wilderness, liberated from human interference,

the Earth's cycles and seasons continue unabated—

Nature's laws ever shine.

❖

Wilderness offers us an empty page or canvas

from which our imaginations can take flight and experiment.

❖

Nature, a vibrant cauldron of forces both visible and invisible,

is to be explored and experienced somatically.

❖

The myriad climates and forces

that create the flowers that bloom then die,

also gust through us as enigmatic energies, instincts and emotions.

Wilderness allows us the opportunity
to empty ourselves as much as possible
of the density of today's noisy distractions
that numb the higher resonance,
to penetrate beneath the surface of things.
When we do, we discover the timeless in time
and hear the lost notes of a cosmic symphony,
the origins reborn in every moment.

❖

We can let our sensibilities flourish in the wilderness
like verdant sprouts of a perennial spring.

❖

Trees rest in the winter, while humans wage war.
Yet perhaps, though unseen by us,
the same polarities exist within the tree's life,
expressed in different forms, cycles and patterns.

❖

The less people interfere with the harmony of the wilderness,
the more God's breath may flow.

❖

When we honor Nature as ourselves,
we inherit the Earth.

15. DIMENSIONAL PERSPECTIVES

With the realization that reality is as one perceives it,
comes a certain liberation, a grace in living.

❖

Ignorance and misunderstanding arise
from assuming that there is only one reality,
instead of realizing that our perceptions and opinions
are merely one facet of a dimensional whole.

❖

We don't see things the way *they* are—but the way *we* are.

❖

If our minds are closed, our perceptions are cramped.

❖

Our interpretations of reality are like clothes we wear
so we won't shiver in the Void.

❖

A painting is the painter; a book is its author.
We re-create what we are.

If more people were aware of the relativity of their viewpoints,
perhaps there would be less tyranny and more democracy.

❖

Emotional reality can be as enigmatic as the climates.
As our seasons revolve, so too may our interpretations.
When we view the endless cycles through the cosmic eye,
our perspectives broaden; our perception becomes holographic.

❖

Rather than live in a one-reality world,
afraid to experience the multidimensional,
we can choose to come and go between realms,
losing them, re-discovering them, and inventing new ones.

❖

We see as we think, illuminating what we perceive
through the lamp of who we are.

❖

At any moment, we can be mind-explorers
diving into the atoms of the ocean floor,
then peering up into the myriad sunlit realities.
We can penetrate the mere surface of things
and illuminate a deeper comprehension.

Our inner light sees
beyond the range of our outer sight.
It is with our inner sight
that we seed our outer blossom.
When our perceptions change,
we see things differently.
And when we see differently, we evolve.

❖

If we address merely external appearances,
how can we comprehend and collaborate on the deeper meaning?
It is unlikely we can share a reality with others
if our assumptions come from a misconception
or ignorance of the greater reality.

16. OBSERVING THE THEATER OF LIFE

Using projection as our tool,
we unconsciously produce the movie we call our lives.

❖

Is there a reality without our projection?

❖

When we perceive reality from the Overview,
we see the humor, the irony
of the outlandish theater we inhabit.

❖

We can be free as birds from within our ribcages,
if our spirits are liberated.

❖

The Pageantry of Existence can be ironic, pathetic and bizarre.
Our ability to witness life with detachment
becomes the priest of our liberation.

❖

The classic archetypal themes do not change—
only the players and their masks, costumes and stage scenery.
Thus is history . . .

Once we are aware of the irony of life,
we can revel more in its marvels.

❖

Life is a tragicomedy.

❖

Regardless of the stage scenery,
we are still puppets of destiny.

❖

The forces of fate use us in their own peculiar way.
In a profound sense, we *do* what we *are*.

❖

We can step aside and observe the theater of human existence,
and then choose whether to get entangled.

17. WORLDLY SEDUCTIONS AND MISDIRECTED DESIRES

When our desires take us out to hunt,
perhaps *we* are the ones getting trapped.

❖

Wanting is itself a thief,
taking from life with misperception what is already there.

❖

Nothing is secure except that which is given up;
all else atrophies in the clasp of fear.

❖

Our world is suffering
from what Buddha called *misdirected* desire.

❖

When we let go of attachment,
our spiritual philosophy provides the bridge
for transition to more expansive worlds.

When fear blocks transition, needs are born.
Healing comes from the realization
that we already have
whatever we need to live our spiritual potential.
If we travel within, the treasure we seek awaits.

❖

Greed parents poverty.

❖

Generosity may spawn avarice
unless handled with discrimination and discretion.

❖

We are employed by our desires.

❖

Lament is unanswered by worldly seductions.

❖

When desire comes from some inward poverty,
it is insatiable.
If we stop thinking we need what is *not*
and enjoy what *is,*
the perception of lack vanishes of its own accord.

With superfluous things, less is more.

❖

Once our basic survival needs are met,
there isn't a lot to need;
the true gems are in the acuity of our senses.

❖

With awareness, we can recognize the ego disguises,
the seductions and distractions
that constantly tempt us off our path.

❖

Seeking can create hunger, but by turning within,
we can cultivate a sacred space, which draws to us what is ours.

❖

In allowing ourselves the ultimate gift of living the timeless,
we can let the burden of misdirected desire and attachment go.

18. SYMPTOMS OF SOCIETY'S DISORDER

Sometimes it seems ludicrous, the things people care about,
the exaggerated value we put on the facades of success,
on being lauded by the systems.
How can we avoid the self-deluding traps of ego?
Are only saints, renegades and other outsiders
capable of rising above their fear-driven survival instincts
and living as free spirits?

❖

How easy it is to wonder about a sense of values
when we see someone showing off his house of impeccable taste,
where all the dead things are being cared for,
and all the live things are dying.

❖

Insensitivity feeds false power, greed and manipulation.
When we seek power outside ourselves,
we are usually attempting to compensate
for the lack of power within.
If power is intrinsic, to capture it outside is unneeded.

❖

Our technology will develop into a more organic Whole
only when we do.

The world's most heinous crimes
have been committed
under the auspices of religious belief systems,
fanatical extremes that run our world.
Interesting how the forces of nature,
wearing these masks,
act out the cosmic theater—
the dance of the polarities.

❖

The warp of wealth and the fragmented
and rusty mechanics of our times
lead to endless waste, economic slavery,
and the need, more than ever,
to liberate our spirits beyond this deterioration.

❖

When severed from our poetic origin,
from the language of symbolism, we lose the true meanings.
Our thinking becomes linear, fragmented and self-destructive,
fueling fanatical belief systems.

❖

With money as our honey, so we buzz,
but what we procure may not be so sweet.

Our gifts may become our shadows
under dire circumstances.

❖

With the accelerated frenzy of our robotic times,
the timeless has been blasted out of the moment.

❖

How fecund life can be,
when despite the world's noise and demands,
we can still be fully present,
vulnerable and sensorially vibrant.

19. LETTING THE GHOSTS ENTER

To recognize our humanity more fully
is to acknowledge and accept our dark side.

❖

Within us exists every force and wild creature.
In ripping apart our cages of prejudice,
we see through to the beast that lurks within.

❖

Prejudice and judgment arise from our denial
of the shadow side of ourselves.

❖

To create our inner kingdom requires inhabiting our shadows,
tracing their origins, and transmuting their energies.

❖

A self-righteous attitude often masks
a defensive underlying violence and insecurity.

❖

When we are able to synchronize our instincts
with our higher consciousness,
we can rise above our fears
and resulting repetitive modes of defense.

We externalize our rivals from our formidable foes within.
We cannot have peace
when we harbor our own competitive politics.

❖

When we feel an aversion, a strong loathing or wrath,
it may be the very element
that we need to acknowledge and heal within ourselves.
Our so-called enemies may embody and reveal
the depersonalized or shadow aspect of ourselves.

❖

We can become friends with the death that lives within,
no longer needing to blame others
for the moonless nights, sunless days.

❖

We can feel more alive, more vital
for exploring the dark passages within,
for allowing the Tao to flow through and enrich us.

20. SUSPENDED CLARITY

Why not relate to ambivalence as suspended clarity.

❖

Indecisiveness may be appropriate as a place of suspension
while we await the answers of cosmic time.

❖

A decision that does not come of its own
should be set aside until it ripens.
The assumption that we must make a decision
may create the problem.
When it is time to act, we are ignited,
and intuition guides us.

❖

He who hesitates may not be lost . . .

21. LIVING WITH PARADOX

Contradiction frees generalizations from their conceptual prisons.

❖

Like a seesaw whose lows make the highs possible,
from our limitations may come our gifts.

❖

We can rely on the constancy of the inconstant.

❖

Creative life force comes from the sustained tension of polarities
and the fashion in which we navigate these forces.

❖

What dark flowers will blossom from this sunny day?
What contradiction will emerge from its opposite?

❖

Every truth, being subjective,
has at least one accompanying protagonist or 'lie.'
All stories of reality are devoted to the dutiful task
of proving themselves right to us.

❖

People make lives out of saying 'yes' to no's.

Life demands that death be its co-creator.

❖

Many a 'virtue' is parented
by a hidden character disorder.

❖

Inherent in the creation of anything is also its annihilation.

❖

The *is not* is also the *Is.*

❖

The Invisible is the pulse of the visible,
seen only by the Spirit's eye.

22. FAITH IN THE TAO

When we cannot change or control something, there is a relief—
peace in our awareness of its autonomy.

❖

The Tao is a converging, yielding, electrical wave;
to sense its current, its will, is to let it take us.

❖

To try to control life, subverts its flow.

❖

When we rise above our fears and interfering will,
we enter a realm where everything falls effortlessly
into a mosaic of meaningful and harmonious design.

❖

What folly to hope that the Grand Forces
will change their currents.

❖

We delude ourselves with the erroneous belief
that we are in charge,
but all the while Destiny is watering the acorn of our being.

Miracles aren't created by the forceful will
or the purpose-filled mind;
they occur when they are ready,
as manifestations of the Greater Cosmos.

❖

When we are in touch with our flame of passion,
the winds of time emit the chords of synchronicity,
mysteriously drawing colleagues and friends to us
as our essential components of mutual mission.

❖

Can we trust the new, quivering flower of ourselves
to grow towards the sun?

❖

It is only when we have hope that we don't need it.

23. GRIST FOR THE SPIRITUAL MILL

Although the abrasive demands of existence
continually threaten our deeper calm,
these challenges may become rungs
on the ladder of self-knowledge.

❖

In suffering, our compassion increases,
enabling us to be more empathetic.
In our empathy for each other, we heal ourselves.

❖

In accepting, rather than struggling against what Is,
we can claim our emerald throne
amidst the imperial gardens within.

❖

When we resist change, we suffer.
Discomfort may be a symptom that we are inhibiting transition.
Yet, when the thorns bleed our intimate chambers,
change is forced into being.

❖

Misfortune or challenge can be the grist for our mill,
the 'abrasion for refinement.'*

*Derived from the phrase, "refining through abrasion," from Benjamin
DeCasseres (1873-1945), philosopher, poet, playwright, journalist.

Survival forces us to change;
without the struggle and rawness, how would we evolve?
These extremes are accelerating,
propelling us through the bottleneck
of personal and worldwide transformation.

❖

When we seek release from earthly suffering,
we can remind ourselves of the need for a Cosmic perspective.
We can remember not to resist pain
but to let it move through us like a wave.
Life is a refining process
through which we are sculpted by the winds and storms.

❖

The gems of poetic treasure are birthed
from the flames of the Earth's black roots.

❖

The Japanese word 'Fudoshin' means
to keep our hearts unshaken before joy or misfortune.
When we live in reverence for the miracle of life
and deepen our understanding of the polarities,
acknowledging that life and death
are merely continuations of each other,
we are able to witness the Tao of forces with neutrality.
Can we remain open in the grist of these challenges?

24. RANDOM MUSINGS

Our connection with the Sublime
is the foundation for all our other relationships.
Our belief systems are but ripples
reflecting this primary relationship.

❖

The wilderness of the unconscious
is lush with the gems of infinity.

❖

How brief our candle's flame; waste not its wick.

❖

How do we distinguish between mission and ambition,
the desire to communicate and the pursuit of self-importance?

❖

I poked a tiny orange crab that matched the surrounding kelp,
and watching it play dead like creatures do,
mused about how often we play dead
in our own peculiar fashions.

❖

We gain nutritional benefit
from the digestion of inspirational philosophies
as well as from the food we consume.

Consciousness is a form of editing.

❖

Why not see mistakes as revelations from the Mystery.

❖

Getting lost can be another way of finding oneself.

❖

When we are alienated, divided against ourselves,
our world becomes barren.
Meaning vanishes without passion, the igniter of the inanimate.

❖

We are more than our appearances—
if we are worth anything at all.

❖

The ordinary, the mechanized can be transformed
by a change of perception, a vibrancy of spirit.
When we are inspired,
even the mundane, the technology of repetition,
can be a quietly exhilarating meditation.

❖

There are many ways one can be militant
without being in the military.

Ah, to be free of our precious virtues!

❖

When a human master holds his dog's leash too tightly,
perhaps he is also attempting to restrain his own instincts.

❖

We are part of a cosmic food chain,
an infinitely expanding aquarium of cannibalistic creatures
in every size and shape imaginable and unimaginable—
all devouring each other.
Our diverse appetites incessantly consume
and assimilate the energy and ideas of others.
We are all predators and prey,
interconnected by our need to survive.

❖

Nothing is separate from its environment.
We digest the consciousness of everything we ingest:
the murdered cow, the slain bird, the news,
the thoughts and belief systems of others.

❖

When we lose our inner 'imp,'
we become imp-potent.

Endless archetypal energies—
from the warlock to the matriarch, to the victim—
are continually teaching us and impelling our behavior.
If we can recognize these dynamics,
we can consciously direct them toward our higher purpose.

❖

Illusions and delusions are the midwives of ambition,
since we project our conditioning onto our future hopes.

❖

When we revere the fathomless Mystery,
words can seem like cumbersome intermediaries.

❖

Why isn't higher intention enough
to seed the rough cobblestone path of life with a friendly moss?
Is it because we don't choose
the archetypal forces that mold our clay?

❖

Our dreams are the songs our hearts play to our souls.

❖

Now is the season for our souls to be nourished,
for the seeds of spirit to birth a new world.

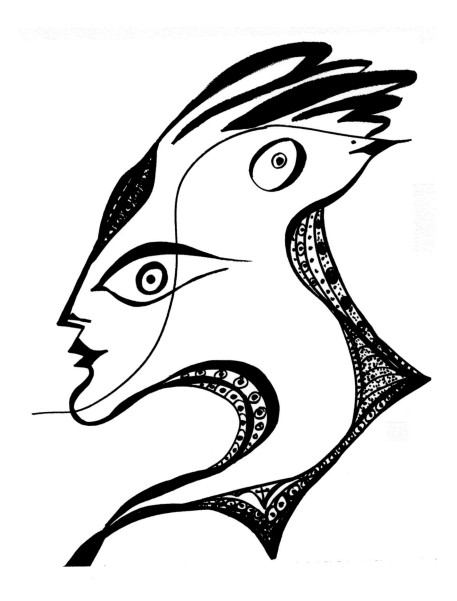

ABOUT THE AUTHOR

Carolyn Mary Kleefeld was born in Catford, England, and grew up in southern California where she studied art and psychology at UCLA. In 1980, she moved to her cliff-side home high above the Pacific Ocean in Big Sur, California, where she studies, writes, and paints amidst the wilderness around her.

With a passion for creative expression and a lifelong fascination with spiritual transformation, she is an award-winning poet and artist, whose books have been used as inspirational texts in universities worldwide and translated into Braille by the Library of Congress. Her art has been featured in galleries and museums nationwide.

PO Box 370
Big Sur, California 93920 USA

(800) 403-3635
(831) 667-2433

info@carolynmarykleefeld.com
www.carolynmarykleefeld.com

OTHER BOOKS BY CAROLYN KLEEFELD

Kissing Darkness: Love Poems and Art *(poetry)*
co-authored with David Wayne Dunn
RIVERWOOD BOOKS, ASHLAND, OR 2003

The Alchemy of Possibility: Reinventing Your Personal Mythology
(prose, poetry and paintings, with quotes from the Tarot and I Ching; can
be used as an oracle), Foreword by Laura Huxley
MERRILL-WEST PUBLISHING, CARMEL, CA 1998

Songs of Ecstasy, Limited Edition *(poetry)*
ATOMS MIRROR ATOMS, INC, CARMEL, CA 1990

Songs of Ecstasy *(art booklet commemorating Carolyn's solo exhibition)*
ATOMS MIRROR ATOMS, INC, CARMEL, CA 1990

Lovers in Evolution *(poetry and Palomar Observatory photographs)*
THE HORSE & BIRD PRESS, LOS ANGELES, CA 1983

Satan Sleeps with the Holy: Word Paintings *(poetry)*
THE HORSE & BIRD PRESS, LOS ANGELES, CA 1982

Climates of the Mind *(poetry and sayings)*
THE HORSE & BIRD PRESS, LOS ANGELES, CA 1979 *(in 4th printing)*

Carolyn is interviewed along with Allen Ginsberg, Terence McKenna,
Timothy Leary, Laura Huxley and others in *Mavericks of the Mind:*
Conversations for the New Millennium by David Jay Brown & Rebecca
Novick. THE CROSSING PRESS, FREEDOM, CA 1993

Carolyn has completed a manuscript of poetry titled *Vagabond Dawns*
and is preparing for publication a book of short stories, fables, poetry
and prose, titled *Psyche of Mirrors: A Promenade of Portraits.*